AMV

Creating a Sense of Place

Creating a Sense of Place

Photographs by Joel Meyerowitz

Smithsonian Institution Press, Washington and London
Published in association with Constance Sullivan Editions

This series was developed and produced for The Smithsonian Institution Press
by Constance Sullivan Editions

Editors:
Constance Sullivan
Susan Weiley
Designed by Katy Homans

First edition

Printed in Italy by TRILOGY S.a.s.

cover: Atlanta, 1988

Why do you choose to photograph a particular place? Why the Cape? Why St. Louis?

You go someplace to be there. You take a vacation. You want to go investigate a middle-sized city. Sometimes you're asked, sometimes you go because there's a change in your life, and you just commit yourself to that change. And then you take the first step when you're there, and that produces a response, and then you have another response. If you like the way the response feels, you keep on opening to it.

There is a dawning awareness that you feel good in this place. Something here makes you attentive, brings you to an awakened state. But you can't know that beforehand. You can fantasize about a place: "Oh I'm going to photograph China." You go there and it's overwhelming, and you don't know why you came, and you feel terribly separate from the whole thing, and foreign. So you make a mistake by projecting ahead. But if you just go to a place because that's the next step in your life, and you're an open person, at least in your photographic life, you begin to ask questions of it. So I think the reasons for going to a place are as normal as those for doing anything else. The way you respond when you're there is more specific. Bells go off that are *precisely* your bells. You are aligned with the inner coordinates of your being, and you suddenly feel in the right place. It may be the slant of the light, it may be even a smell, something not visible; you may feel yourself rooted to the spot where suddenly there's a smell of salt water mixed with roses, and it's got your number. At that moment you know, "I'm alive. Here, now." And what's there? Whatever you make of it. Sometimes it's ephemeral and nonvisible. Ordinary.

Did you know the Cape when you started photographing it?

No, it was totally new to me. I went because I was undergoing some changes in my life in terms of questions I was asking about photography, and there were certain things I had to give up, and I had to be ruthless about it. In order to do that I had to work away from New York City for a while. I knew that the time and work that a view camera required did not allow me to work in a big city in the same way that I had worked with a 35mm camera. So I had to abandon that notion completely and take myself to a place where life was simple, where life moved more slowly, where there was a chance to use this tool

and to see differently. I had no idea what it was going to look like. I even kidded myself thinking I would go to Provincetown and work on the street, because it was busy, but smaller. I thought it was manageable. I hardly made any pictures on the street. Everything else seemed to call to me. And I believe these things are related in part to the instrument we choose to work with. An 8 × 10 camera isn't for horse races. You do what it tells you to do.

How did you happen to photograph St. Louis and Atlanta?

They were commissions. Someone asked me, "Can you open yourself up to this place? Would you like to come here? Is this a place you could work?" I felt the call to St. Louis before I had any reason to work there. That size city, with that look and that light gave me a visceral reaction. That came first. A chance sharing of that reaction with someone in the photography community led to a meeting with the director of the museum, who then was able to offer me the chance to come there. He saw something in the work that he responded to. He was from the Cape originally so he read the Cape in my photographs, and then he saw St. Louis, where he was, and made some connection.

There really are spatial relationships, and a similar feeling in the photographs of both places.

Right. I remember my very first feeling in St. Louis. I went with a friend to do some research, and downtown St. Louis is filled with spaces. You could stand on one edge of the city, and I swear that you could look right through the downtown section—not as the street goes, but in between the buildings you could see block after block of missing pieces. There was spaciousness. I love cities. I love New York City for its energy and its density, and here was a city that was pretending to be dense. It didn't expose any energy to me right away, certainly not in terms of people, but it had these sight lines through it and those plunging spatial openings called to me, very much like the Cape does. The Cape often speaks to me as a space between two buildings. I look out and there's a whoosh, right out to the horizon line: two little cottages holding the horizon line at bay. And I'm sure, by the way, that Hans Hofmann worked off of this energy. He lived and taught in Provincetown, and what you

see between the buildings are these pulses of energy—blue spaces or red spaces, depending on the sky color—and I just go whistling out those alleys into space. St. Louis did the same thing to me. So maybe there is something in me that responds *profoundly* to any opening there is into a deep space. And if there is some blockage in front, in my language—something to prevent me from going through—and then there's an opening, I feel my way through. Maybe that's my temperament. Maybe that's the thing that sets those bells ringing.

What led to your change from working in black-and-white 35mm on city streets to using an 8 × 10-inch view camera and color?

I'd been working in both color and black and white for a long time, but shifted to using only color on the street. At the beginning of the 1970s I had been seeking a high quality of description using Kodachrome 35mm, which was an extraordinary material in those days. However, I couldn't get what I wanted on a print—they had to be dye transfers and were too expensive. So there were a number of issues, mechanical and technical, that were interceding. I tried working with a medium-format camera in 1970—a 6 × 9 cm camera using color negative film—because just about that time I began making prints in my darkroom. But that camera was so slow that I began to lose the kind of image that I was making on the street. I decided, "If I'm going to put this camera on a tripod, I might as well put a big camera on a tripod, and get back *all* the description." Consequently I got an 8 × 10 and began to photograph.

Working with 35mm calls up a specific energy and the freedom of making a gesture with a camera. You hold a small camera in your hand, something happens in front of you, and click, you take a picture. A hand-held camera allows you to react in a split second. With an 8 × 10 camera your approach to things is much more meditative. The basic difference was one of mechanics at first. What you can do with a small camera in your hand you can't do with an 8 × 10 big box on a five-foot high tripod. But for me there was the need to bring one experience to bear on the other. I saw in the 35mm color a kind of quality of description that 35mm black and white didn't have. Something about the way Kodachrome II described things was so cohesive, grainless, smooth, creamy. The color itself added this extra dimension of de-

7

scription. A red coat in yellow sunlight and blue shadows didn't come out medium gray, it came out exciting and stimulating. I thought, "I want to describe that in my photographs too." And my argument from the early 1970s on was that color was significant. It just needed to become tangible. A slide on a screen in a dark room is intangible: it goes on for thirty seconds or a minute, no one gets up to look at a picture on the wall, and when it goes away you forget about it. But you can hold a print in your hand. I wanted to bring the values of the color slide into color prints. At the right moment all the right elements were there. So I began to do it myself. By using the view camera I gave up the instantaneous gestural response to things that I produced with the 35mm. But what I tried to bring to the 8 × 10 was the same sensation of immediacy. If I was struck by something, I tried to have the 8 × 10 camera ready to make a picture quickly. I felt I was bringing a street attitude to the 8 × 10.

Do you carry the 8 × 10 camera around with you?

I carry it with me as I would carry a 35mm camera. In the very beginning, if I went for a drive or to the A&P, the camera was in the back seat of the car; if I went for a walk down the street to visit a neighbor, or if I went to the beach, the camera was on my shoulder. No matter where I went, that camera was ever-present: parties, walks, shopping. It came from the discipline of carrying a 35mm at all times—in the early years you never saw me without a camera. I didn't want to be in that position of saying, "Oh I saw a great shot, if only I had my camera." At that time no photographer was without a camera. We got that from Henri Cartier-Bresson's being ready for "the decisive moment," and from Robert Frank's traveling everywhere in America and making pictures of the Americans that seemed to occur in the most unexpected moments. Since my discipline was always to carry a camera, it didn't matter that when the size changed it became big and awkward; I still wanted to have it at all times. So I provided myself with the opportunity of making large-scale, highly detailed photographs of unusual moments.

Were you aware of looking for another way to photograph, or other subject matter, because of the view camera?

I didn't think of myself as becoming a landscape photographer. I thought I was going off to photograph whatever came my way. My understanding of a landscape owes a lot to Edward Weston. West Coast photographers made landscapes. They made monuments out of the monuments of nature, whether it was the grandeur of Yosemite or lichen on a rock. That was the way to photograph landscape, and I wasn't Eliot Porter looking at the reflections in a pool. It wasn't on my mind at all; I had no reason to think that was for me. The Cape didn't look like that. The Cape was fairly spare: a couple of sand bars, some sand dunes, water and sky, and empty old houses. I wasn't interested in turned-over boats. That isn't a theme or motif that interests me—it's old and dated and part of painting. But you have to deal with what's in front of you, so the harder I looked the more I began to see.

In a sense the camera taught me how to see. I tried to bring something to it, which was energy and decisiveness and immediacy—things that a small camera taught me. The 8 × 10 taught me reverence, patience, and meditation. It added another dimension to the scene, and the pictures are a product of two conditions, awareness and time. I had to modify my early discipline. Every artist's growing process involves giving up something to get something else. You're giving up your prejudices and preconceptions, and if you refuse to give those up then you don't grow. You stay where you are.

Your 35mm work is concerned with incident— something that happens at a particular moment. The large-format photographs are more about being in a place and just looking at it.

One can never get enough of the human comedy, because every day it comes in a different package: its tragedies and humor, its spontaneous unfoldings and awakenings. That happens in a kind of jazz-like way. When working with a small camera you suddenly are aware of a riff going on in the street, and how it makes you feel. You respond to that. With a view camera you're defeated. These instantaneous incidents are erased by time. A little camera can capture them in 1/1000 of a second, which is a heartbeat, a blink, a catch of a breath. With the view camera you have to snare the subject with time and a deep

9

f-stop so that you have something there consistent with the nature of the machine. It's a different way of seeing things. My sense of timing, my distance from the subject matter—all these things went through changes. In fact, the shift from black and white to color in 35mm also engaged those very same changes because you can rate black and white film at 1600 ASA; color has an ASA of 25. We're talking about almost eight stops difference, and that required slowing down. Working with color required me to be stiller, more distant from the action. No longer could I charge in and photograph three people five feet from me. I had to play everything back in order to get any kind of description. Description is the key word for me, and I owe my awareness of that word to John Szarkowski [Director of the Department of Photography at the Museum of Modern Art, New York]. I think one comes to it by making pictures, but John used that in his arguments of the 1960s over and over again. In his books *The Photographer's Eye* and *Looking at Photographs*, description comes up again and again.

Do your photographs describe what you experience as reality?

Yes. Photographs describe what awareness perceives: it's a photograph of one's awareness. It just *looks like* the objects in the photograph. I don't know if it's everyone's reality. In fact that's what's so shocking about looking at other people's photographs. That's what *they see?* That's what stops *them*? And if they engage you enough you say, "It's interesting that they stopped to look at all those things. What a curious mind they have." Or if you're bored by the work, "What a boring mind they have."

My pictures reflect the sum of my life experience. When I take a picture at 1/1000 of a second with a 35mm Leica I'm photographing my sense of what life at 1/1000 of a second looks like—what coheres in the frame at that moment. When I photograph something that takes me seconds, or minutes, I have a whole different perception of time, of breathing in and out. There's lots of room in that time. I can stand for a while and consider it, whereas walking around on the street consideration is instantaneous. Something happens, and as it's happening you are *in* the perception of it.

Somehow your sixth sense is there, and that is faster than 1/1000 of a second, which is slow by comparison. The electrical impulses in our brain jump much faster than 1/1000 of a second, so the gesture of your hand reaching for a camera and bringing it up to your eye while turning around and

pressing a button is slow. And yet we can have what appears to be an instantaneous recognition of things that come to have meaning. If we really look at Henri Cartier-Bresson or Robert Frank or Garry Winogrand or Lee Friedlander, we recognize that these photographers were, in a split second, on to something—and that they were on to it consistently. In picture after picture we see the working out of their instincts, their awareness, their intelligence, their intuition—all of these things, which are somewhat ephemeral. And yet they're hard facts; they were all being smudged and erased by time, but the camera made them appear hard. They leave us a little room to enter the experience ourselves, as if it were a reality.

What I think is so extraordinary about the photograph is that we have a piece of paper with this image adhered to it, etched on it, which interposes itself into the plane of time that we are actually in at that moment. Even if it comes from as far back as 150 years ago, or as recently as yesterday, or a minute before as a Polaroid color photograph, suddenly you bring it into your experience. You look at it, and all around the real world is humming, buzzing and moving, and yet in this little frame there is a stillness that *looks like* the world. That connection, that collision, that interfacing, is one of the most astonishing things we can experience.

What stops you? What do you stop to photograph?

We walk through our lives as if we're in a Japanese scroll. It's just rolling by. Every dimension is coming at us—360 degrees around us—and life is just flowing by. At any given moment, there is the possibility to say, "Ah!" You catch your breath. You are inspired. You are at that moment suddenly feeling alive and aware and awake. Something, some connection with the whole, has pressed itself to your senses. In that moment, there's the tiniest little change—so tiny, it's been smothered by all the energy around you—at that moment you stop, and say, "What's here? Why here?" It doesn't require your eyes, it requires your sense. You know this feels good. By looking through the camera you begin to take the measure of the place. If you move the camera a little to the left, if you move it to the right, it all changes. All you have to have is the courage to say, "*This* is the place."

If you were to sum up the parts of some of my pictures—a fencepost and sunlight and clouds, a young girl standing by the edge of the road, the back of the baseball screen—they're descriptions of ordinary things. But

they're about my inner connections. I'm bringing my whole life to bear on that split second. Everything I *am*—fifty years of life, twenty-five years of photography, all is brought to bear when I press the shutter. If you think you can photograph without them, you get an empty photograph. No calories, no significance. No *significance*. These pictures are signs that you came to consciousness for a brief second in the flow of your life, which is so overloaded with stimuli that it can drive you away from concentration. And if you can be focused again and again, you'll be able to look down the line of your pictures, and see your particular focus, your sign, and know that you are the *signifier*.

How do you determine where you stand in relationship to what you're photographing?

You know when you're there. It's the dance. It's the conversation. Very human terms are the motivation and the response. When you go to a party and you talk to somebody, you stand at a social distance. Or, if there's some opening from that person, and you feel connected in some other way, you may get slightly closer and speak in a more intimate way. Or if you dance with someone, you may dance close or you may dance at a social distance. You feel it out. It's like walking on ice. You really have to feel your way.

I'd say in the last ten years I've learned to photograph without looking (that doesn't mean not seeing). I walk though my life, wherever I am, the camera is on my shoulder, and I am just *there*. And at some given moment I sense that I've walked into a zone of energy that stops me. I suddenly lose my forward momentum. There's no reason to go forward. It's not something I eyeball. It's not a bunch of red flowers, or some *thing* that's kicking off energy. It's a field of *force* that I *enter*, and I cannot go forward. Sometimes when you walk on the streets of New York, and you walk under construction scaffolding, you step in, and at the place where the door leads into the site you smell the smell of wet concrete, of acetylene torches, and of the dust of construction. It's a very palpable, powerful smell. You step under the scaffolding and there's nothing; you hit the door and there's a smell of everything; and then you take one more step and there's no smell. You've left the zone. A current of air has been rushing across the path that you're on.

I don't mean to be mystical, but I feel there is a current of energy in a field that I enter, and when I hit that space I say, "Whoa, something is here. What is here?" The first thing that's there is me. So now I find an opportunity

to put the camera down and see what it is that's defining me. And every time I do that I make a picture that has some special meaning to me. They may not be great pictures, but they *mean* something to me. When I look at them afterwards, I *know* I was in the right place at the right time, and I use *that* measure to allow it to come into being, to stop myself from pushing through it. Because the easiest thing is to be blind, and to keep right on rolling until you get to someplace that's a familiar, observable reality. But this is not an observable reality; it's a sensory reality. I trust that now, more than any other form of approach.

Does that sensory reality change when you photograph a person, and they're standing in front of you, as opposed to when you photograph a landscape?

It's true they're up front because we're in communication, we're in contact with each other. It's an intimate moment. But the choice of that person is not unlike the awareness of that sensory reality. Walk along the street or the beach, and you're not prepared to know who's coming next. And then you see somebody, and you're awakened by their presence, by whatever human scent they give off to you. Your response is primarily what you're really interested in, what you're engaged by. You have to be courageous enough to go toward them. It means penetrating the space between the two of you. That person doesn't know you're coming. They don't know that you got some sensation coming from them, so you have to break the distance, you have to ask the question, you have to make your needs felt. Without working too hard you have to convince them that they're necessary to you, and that this is necessary to them, so that they care to give up something of themselves to this person with a camera. It requires the same right approach to get to a person as to a landscape.

How does the description change?

If you're willing to look at that person, once you've made the agreement, with a sense of wonder so that the element of surprise and potential remain as open-ended as when you are photographing the presence of a place, then that's what it's all about. You're going to be surprised. Now that you've made

the connection, now what? You ask the person to stand there, and you wait patiently for him to reveal himself. If he trusts you he may somehow relinquish something of his inner truth. And now we're treading on dangerous territory to speak of truth at all, because whose truth is it, and how true is it, and what standard do you call truth? But you recognize something at that moment—that's your truth. And it may be that you recognize only what he reveals, which may be a fragment of his truth. So there's a chance for an alignment, a brief encounter, of two sentient beings in touch, even if one is a child. You may cross that space, and it's the gamble. It's the same gamble you take when you make a photograph in the world. You don't know if you're going to get back anything from that, it's just odds and ends.

You're not trying to get them to react in a certain way.

Right. I don't believe in a display of personality. That's not what these pictures are about, to give a big gesture and some kind of reward to the viewer. I'm looking to see the humility, the ordinariness of these people.

Or the ordinariness of clothes hanging on a clothesline.

Who knows what's going to leave us spellbound at any given moment. Everything has power—even the most common object: a fencepost, a picket fence, a street lamp. There are things that suddenly have an erect and present force, which comes only when you pay attention. Those clothes flapping in the breeze on that line spoke to me as very few things have ever spoken to me. I stood in front of them watching them dance. They *were* the description of wind. The wind was filling them up and snapping them around and they were dancing on that line. And so I saw the natural force trapped in the shape of these towels and sheets, and I was mesmerized. I stood there watching this and suddenly I snapped to and I thought, "I could photograph that!" A moment before that I was just standing, dazzled by the most ordinary thing, and if I had said to myself, "I'm now going to take a picture of some bedsheets and some towels," I would have laughed. I mean what the hell is that anyway? But I couldn't take my eyes from it, and I had to honor that observation, because it was new to me. It was as fresh as they come, as fresh as the air that was rolling around those sheets. And so that picture became a reality to

me. I think what it feeds into is *not* having preconceptions. It's using the Zen swordsman's motif: Expect Nothing, Be Ready for Anything. It's a basic way to go about your life if you're a photographer—or just to go about your life. Don't expect anything, because then you freeze it. You hold things back with expectations.

Your approach to photographing landscapes is different from Edward Weston's and Ansel Adams's.

When I photograph in a landscape I don't have the history and stance of Adams and Weston and Porter, because I think they have a more majestic view, a more idealized view. They went out into nature in the Romantic tradition, which was to go into nature to make your work, to use what's there. But they also felt they wanted to control this and to poeticize this. They had a reason to make photographs. They were intellectual about it. I'm visceral. I just go, and if I see something I don't ask what it means. They came at a time when the printed word was the strongest communicator of thought. And by the time they reached this place in our century, the visual image was the strongest communicator. Now the moving visual image is stronger than the still moving image. They came at a time when those conventions of nature, the description of it, had a different meaning. If you look at my whole generation, what's interesting is the way we look at landscape. Robert Adams looks at landscape by seeing the damage that's been done, the abuse. It's a celebration of what it looks like in spite of the fact that man has left track marks.

There is inner space and there is outer space. The macrocosm of the universe and the microcosm of the inner universe, and we are just one thin plane somewhere in the middle—not the middle, but one of the many middles. I think that when we travel someplace, we're in the middle. We're not at home, we're not completely at home in the place that we're in, but we're still ourselves. We bring that along with us. If you feel balanced and confident enough about your capacity to examine in this place, you'll examine yourself there—you'll ask, "How do I feel about being here?"—without making a judgment. I think it's important to slice this really fine. To work in St. Louis or Atlanta is not to cast judgment—"Oh this isn't as good as New York, or Boston," or "It's ugly." Every place has those qualities. It just is. And if you're there, and you honor your experience, you might just see wonders in the least likely places. And bit by bit you begin to know something about your feelings

in that place. Perhaps the place makes you feel good, or perhaps it constantly drives you away.

For instance, in Atlanta I could not go downtown and work. Every time I went down there I was driven away by the inhumanity of it—the dehumanized scale. The buildings were too big and too close to each other, the streets were all in deep shadow, there were no pedestrians on the street because everything had been designed with interior passageways—malls, crossovers above the street. It's a hot place in the summer, so there are a lot of air-conditioned underpasses. People move like ants through the subterranean tunnels and buildings. The street held little charm for me. On the street I felt isolated. It felt dreary to me. Every time I went downtown and tried to work I fled. At some point I realized I didn't want to go downtown; it was not part of the map for me. So the map I created of Atlanta doesn't have downtown on it. It didn't feel good down there. I didn't work there. It comes back to that same thing: listening to your feelings. That doesn't mean you shouldn't question them, of course you should; sometimes you have to overturn some of your resistance. But I think I honored the question frequently. I try to do that.

Are you ever in the midst of working in a particular place and you get the feeling you're not getting anything, you don't feel connected to it?

That's just ordinary human life. You feel stimulated or aroused or connected. I may feel the place is foreign, or that it seems bigger to me, or that I'll never get to know it, or that I'm just an insignificant pea in this pod. "What am I doing here? Why did I come in the first place? This is no place for a vacation." We've said it a million ways. And then suddenly I turn a corner, and there's a great café with a view. I sit down and have a coffee and suddenly I'm so happy I came away, just because I'm sitting in this café. I can turn a corner and suddenly see the wittiest, craziest, zaniest place and think, "I want to go there." Suddenly I'm in that place. It's like waking up. Maybe most of it is a bad dream. And then suddenly I come alive to it: I've made the cross over, I've just slipped over to the other side. And from then on I have a way of reviving my excitement. Then it's two months later, the season is different, I'm different by two months, and I use the experience of having been there once before, and build on that.

I think all cumulative works of intelligence—photographs, paintings, mu-

sic, literature—are about building on your experience, redefining it for your-self, and looking at it by holding up this crystal and turning it around and saying, "Why is it different now?" Or, "What's different about it?" Inquiry, a mode of inquiry, is important to both the medium and the practice of it and the experience that you're having. If you're not curious, what do you make? Boring photographs.

What do you look for in a photograph? What has to go on in a frame to make it interesting?

It's a merger of what's inside your head and what's outside your eyes, and finding a way of synthesizing that experience—because what's inside your head isn't something that you have predetermined you want to have. It's a no-tion of what's satisfying, what fills you up. I think about photographs as being full, or empty. You picture something in a frame and it's got lots of account-ing going on in it—stones and buildings and trees and air—but that's not what fills up a frame. You fill up the frame with feelings, energy, discovery, and risk, and leave room enough for someone else to get in there. It's full be-cause you're there, because you carried a lifetime of impulses with you that direct you toward the way the light is falling on that particular surface of that building, or toward the clear sky behind you. You don't know why, but you turn to it. And in the course of turning you may make some observations about everything else around you, because you're finally looking at some thing, at some place, that has cut itself out of the 360-degree panorama around you. There's seventy degrees, let's say, that's really interesting. And as you take that in, you begin to see it's relationship to everything else. The *it* of the photograph resembles you. It's your quadrant. So you have now held onto that, and later on you have proof—a picture—of what you held on to, and when you look at that picture, it begins to speak to you now, separate from the experience—you no longer are standing in the surround, you're in your apartment or studio, looking at the photograph.

And now it has to have another set of characteristics. It has to play with the observation, the variables that make a photograph interesting: simple de-scription of beautiful places—there are many things that you hold dear as photographic quality that will urge itself on you because it's got something that's particularly connected to your way of looking. And that becomes a notch in your belt. And then another one, and another one. If you give it free

play out in the world—without questioning it to death, just questioning its sense of rightness—you'll provide for yourself a scheme of images that you can weave your tapestry out of later on. You'll provide yourself with the warp and the woof, to continue the analogy, so you can continue to dance from strand to strand. This one here, but not there; this one here, but not that, until you organize a body of work that's based on your original intuition and has been built through your growing intelligence about the place. You're a sort of central intelligence agency: you're soaking up all the stuff in the place, not only what you're photographing, but your smells of the place, the meals you had, the rooms you stay in—all the visits are giving you a picture, and the photographs you make are being built like some kind of sand castle, grain upon grain upon grain. It's getting bigger and bigger. Finally you've got this enormous pyramid of images, and you're putting one more on top—that's you. So it gets higher and higher and higher, but it's also getting wider and deeper and denser. At a certain moment you say, "Stop." The instinct to stop comes when you feel full. You don't have to make another image in this place. Sometimes finances cut if off, sometimes the experience, sometimes the amount of time you really have. Whatever it is that brings it to an end, you then have all the work to look at. I believe the important thing to do at that moment is to sit down with those pictures and read them and not make judgments.

How do you edit? How do you choose the handful that say what was really going on for you?

I spent two months with 409 photographs. I sat every day and I would look at fifty or sixty pictures very carefully, until I got to know them. Good ones, bad ones, it didn't matter. I looked and looked, and I began to see what the experience of Atlanta was. I had conceived these pictures, now I had to give them room to interact with each other. They were teaching me what Atlanta looked like to me. I slowly culled, and when I had 100 pictures out of the 400, I started to look for the photographic properties as well as their *telling* characteristics: how firmly do they put pressure on the photographic idea? What does Atlanta look like? What does photography mean to me? Those were the two poles of my questions. The rational one—"Atlanta is pictured here; does this look like it?"—and "Why is this necessary as a photograph?" If you can keep that dialectic sustained in your own work, you'll finally make some

choices based on the photographic properties as well as on nature, sense of place, presence of place.

What makes a photograph convincing, or evocative of real experience?

A photograph must have room in it for entrance by outsiders, so that the photographer himself or herself hasn't built a structure that keeps you out, but instead has left some crack that allows you the freedom to enter. He or she hasn't held on too tightly. I heard a quote from Peter Mathiessen, who said that when you climb a mountain the first rule is "Don't cling." You have to climb a mountain free, as if you're just taking a walk on the beach. And I think if a photograph is made by a photographer who is trying to give you a message, you get that message but you don't have a real experience.

There's a balance between a specificity of description or detail and feeling in your work.

I think there's a connection between the two. There are two paths of intelligence and energy there, and when they come together—if you give them room to come together—the feeling and observation, you can make a spark that is itself intelligence. In a sense a picture like the baseball field is, to me, an idea. I ask, "How can I take what's right in front of me, this net that's covering the entire field?" I wondered. A sensation of net is what I felt when I walked into that place. I saw the world through the screen, but I also saw that there was a world behind the screen. "How can I take that building, which was a mile away, and bring it up to the screen? Can I make a picture of these two things that are so far apart?" So my intelligence comes into play, and I try to make space, which is deep, elastic enough to bring together these elements in the same frame, to make a photograph.

A photograph exists on one plane. That's all it has. It has no depth, only the illusion of depth. So I tried to bring these two things, near and far, together. And by bringing them together, I'm not diminishing their power. By making them come at the same time to the same place, I am photographing an *idea*. Added to the idea is real events: the men who were running. I could choose not to have anybody in the frame, just have a plastic description of near and far; or I could allow for this wild thing, this beast of inspiration to

come into the picture. And then they'll run through again, I knew, because they ran around the field and they were coming back. So I waited and I took a picture of them coming through. But this picture isn't about the screen, and it isn't about the building. It's about the struggle to make something interesting using all the elements available. Without that you only have description. The camera will describe what's in front of it, but *you* have to have an idea.

There seems to me to be a palpable sensuality in your pictures, the sensation of something being touched physically.

I think I'm particularly vulnerable to that sensation. I've had it since I was a child. I was the kind of kid who stroked and loved everything. I would drag my hands over things, rough or smooth, and constantly hold things in my hands. I'm very tactile. I'm caught up in that. I'm easily brought to tears by things I photograph. It's as if there is an *anima* in still things, and their liveliness and energy stroke me. And I stroke back. It's like a secret. You don't want to expose how vulnerable you are. But when I stop to photograph it's generally because I'm mobilized by the thing. I'm overwhelmed by it. I'm holding it in some way, and in that holding response is the caress, that sensuality. If one gets a reading of that from the pictures, then I have to accept that that's the underlying theme. I can't help myself. It's just an outgrowth of the person I've become. I think I've become aware of it, but it isn't something you can force. You're surprised every time. You're also surprised by the *nature* of sensuality. You never know where you're going to find it. It isn't in velvets and flowers alone. It could be in a wire screen of a baseball field, it could be in the way light moves across water, or the way grass grows. It's in nuances. It's at the heart of the work.

In what ways have you changed your responses to the world over the years?

I have been thinking about what a photographer's responsibility is—his social responsibility, the responsibility to the craft, to the telling of the message, to the print. Although I started with what I thought was a moral imperative, that America was this crazy place that needed to be described and I had a social responsibility to tell it as it is—the Great American Novel in photographs—somehow over time, during my middle years, the aesthetics of photography

20

played a greater role, and I became less concerned with serving moral issues.

And as I got a little older, it has become more important to me again to be morally conscious—not to vacate that responsibility, but to say, "These are my feelings about it. This is what America looks like right now. These are things that are socially reprehensible. These are things that might be overturned." If you don't point them out, if you only glaze the surface, the beauty of light or the beauty of the subject, you don't see what might need to be corrected, or what can be changed, or what's really wrong. An artist's responsibility is to not avert his gaze. Maybe you can't correct it by pointing it out, but you can at least certify that you saw it at that time, and that it was painful to you. I felt in Atlanta a reawakening of moral responsibility. I felt it was important for me to go to the malls, it was important for me to look hard at construction, at building materials, and to see the way neighborhoods were being put together, to see the anonymity of streets, the emptiness of what really passes for everyday life. I wanted to find a way of telling what I saw, or of keeping it alive in the photographs. In some ways I think I had lost a connection to that responsibility. I think it's important to take a turn. For a period of ten years, in the middle, I was so engaged with the inner argument of photography: "Why photograph? What does a photograph look like? What makes it photographic?" These issues numb somehow. It's not that I was dulled to photography, but to the world. Making photographs was all. I think I lost touch with the outside world. I've come back out in the last four or five years, with smaller works, and a deeper sense of real contact and community.

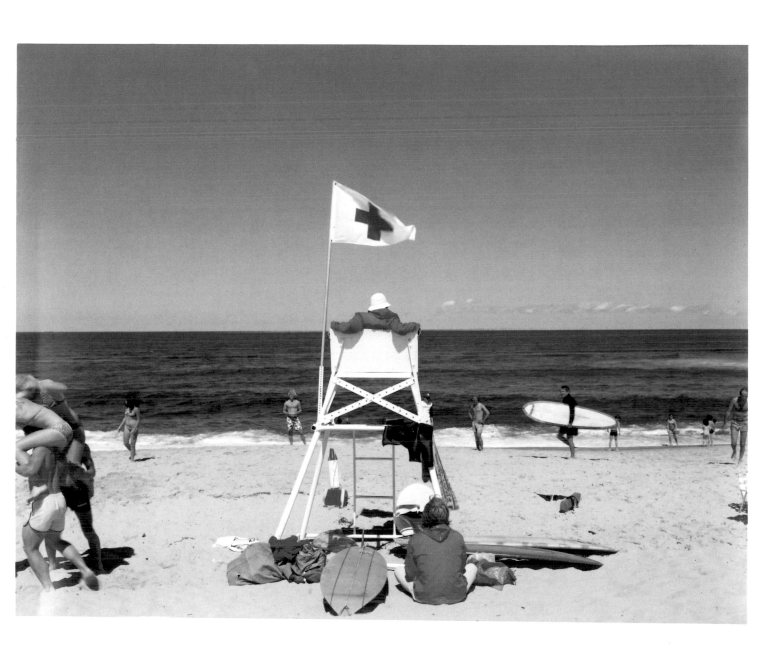

Ballston Beach, Truro, 1976

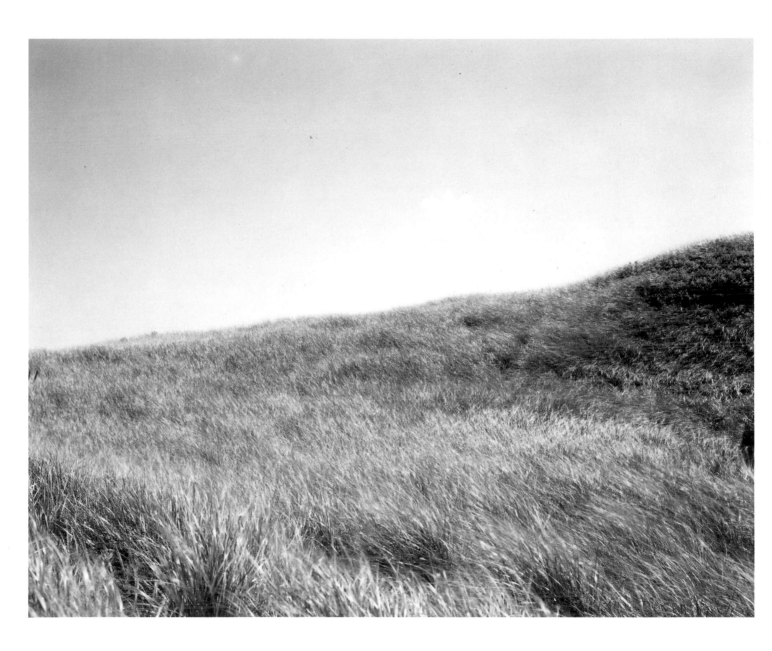

25 **Truro, 1984**

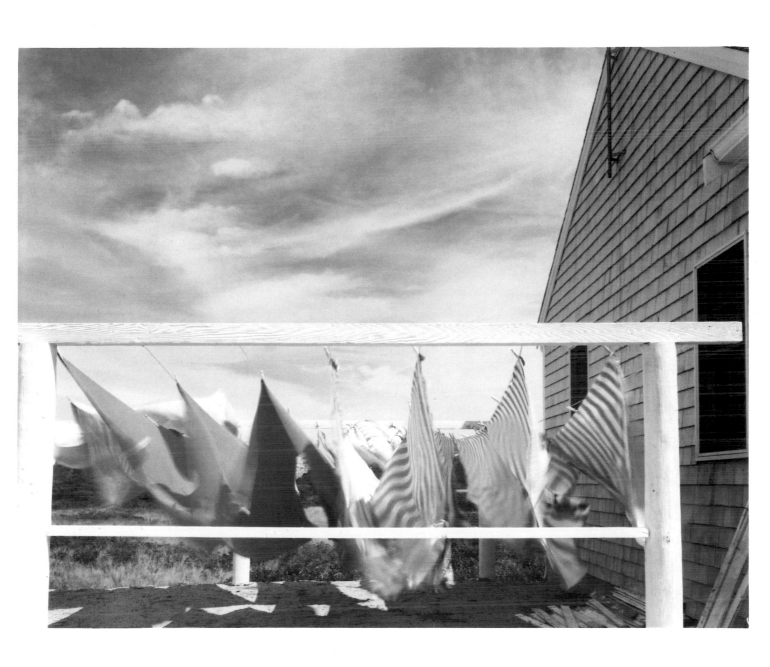

Provincetown, 1977

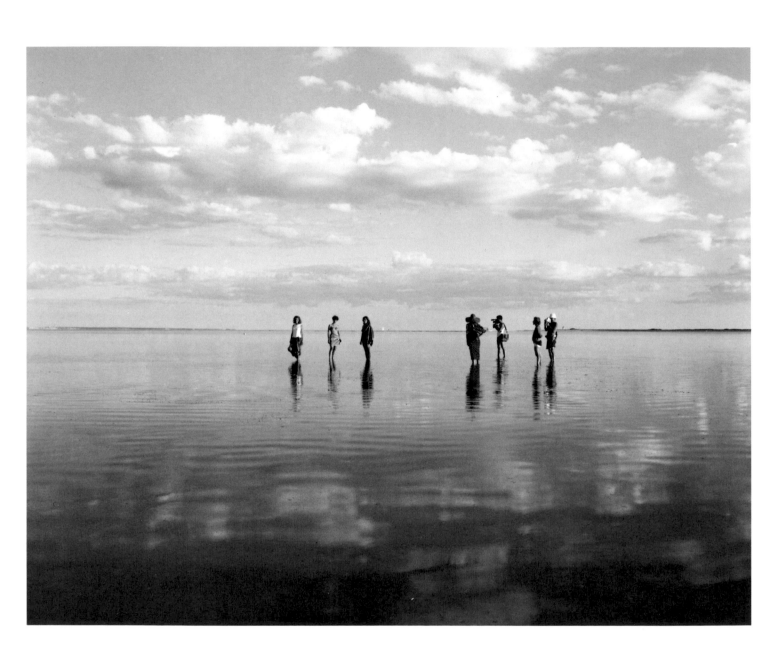

Provincetown, 1986

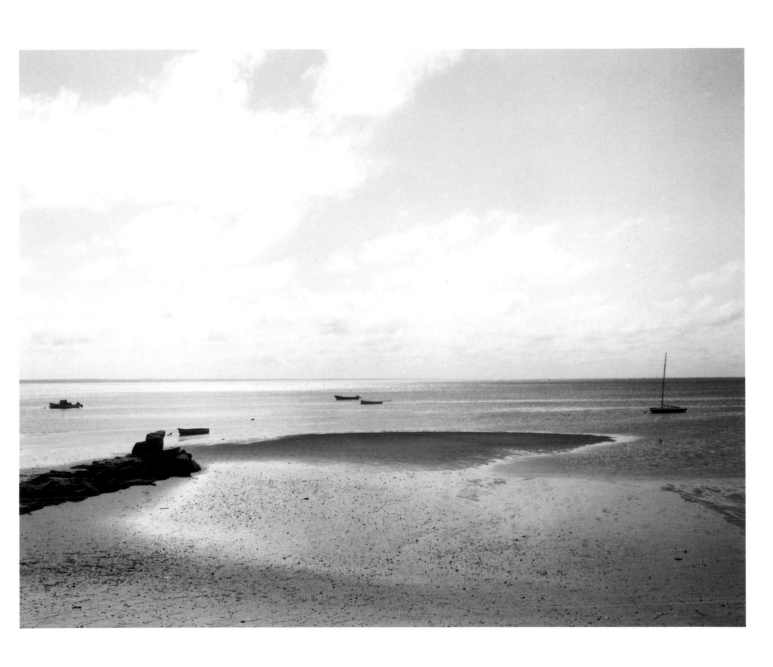

Provincetown, 1983

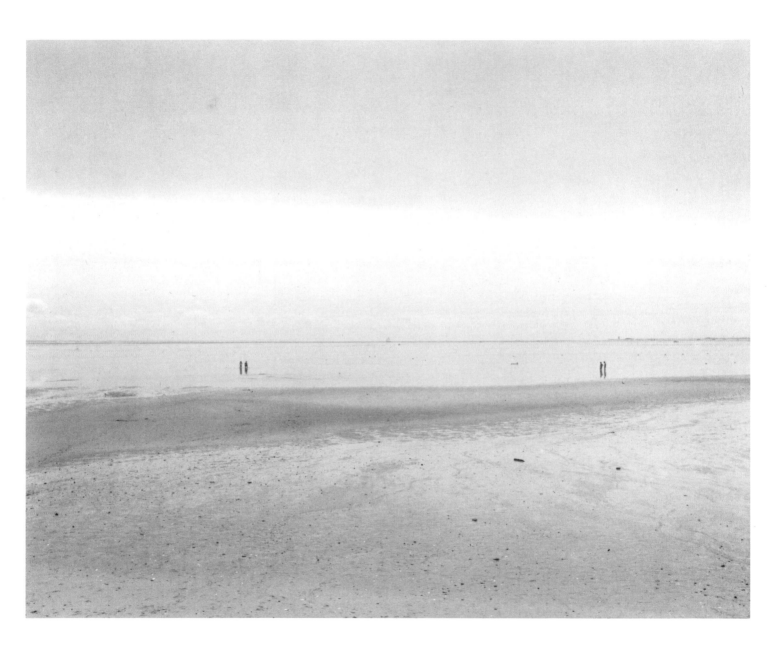

31 **Provincetown, 1984**

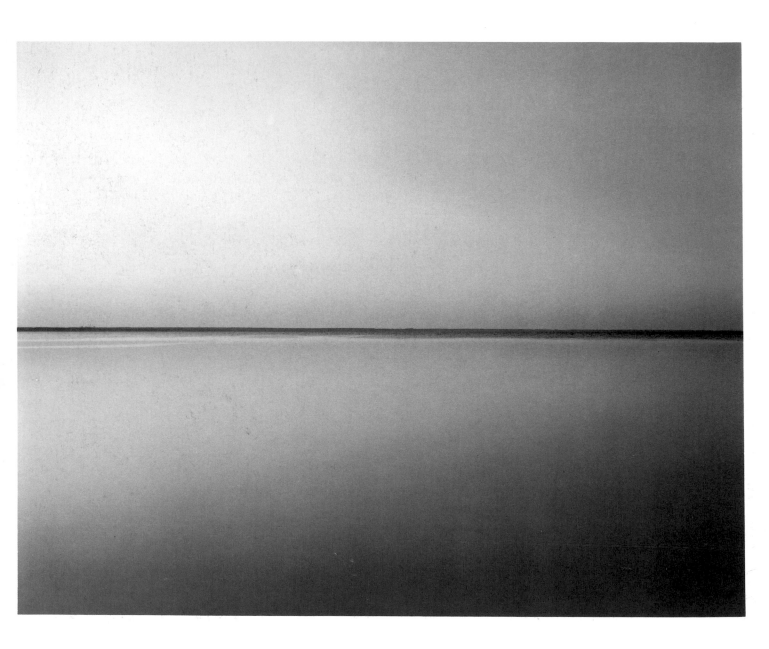

32 **Provincetown, 1985**

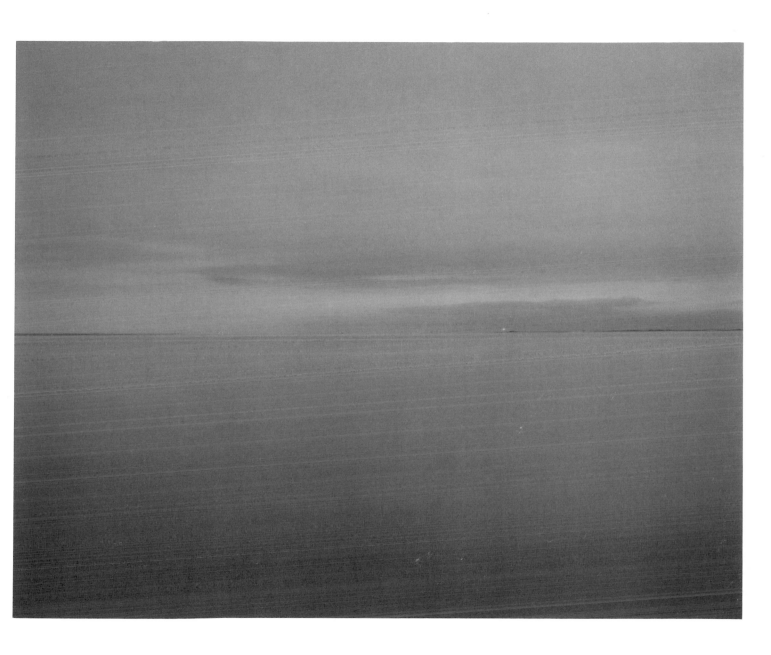

Provincetown, 1984

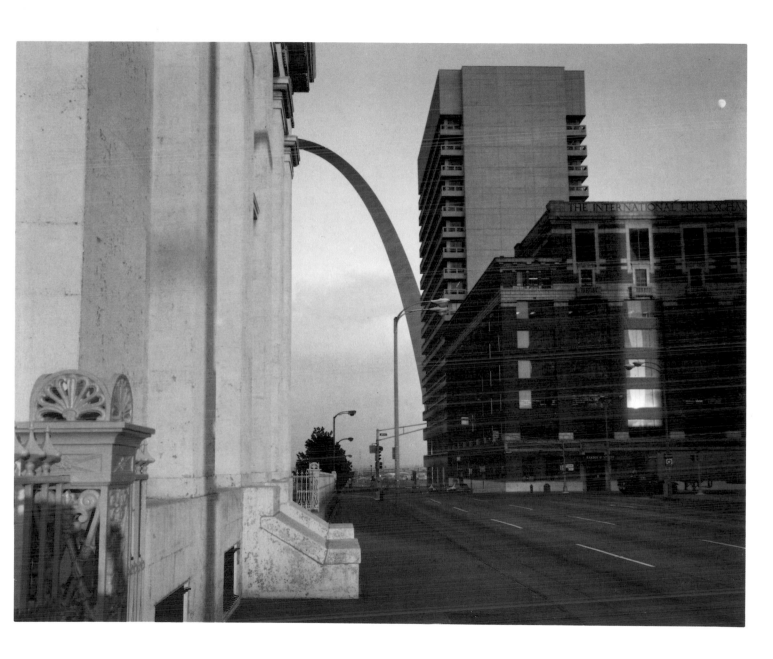

St. Louis, 1977

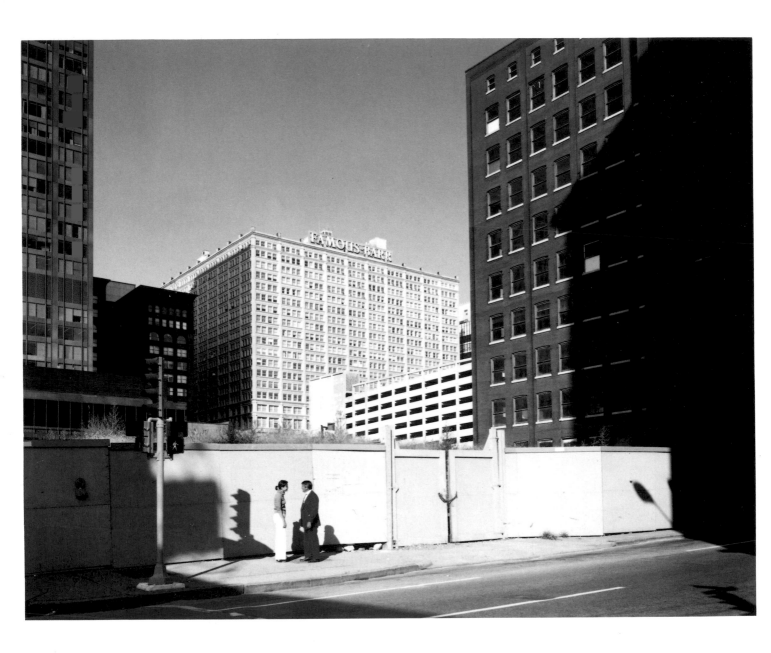

St. Louis, 1977

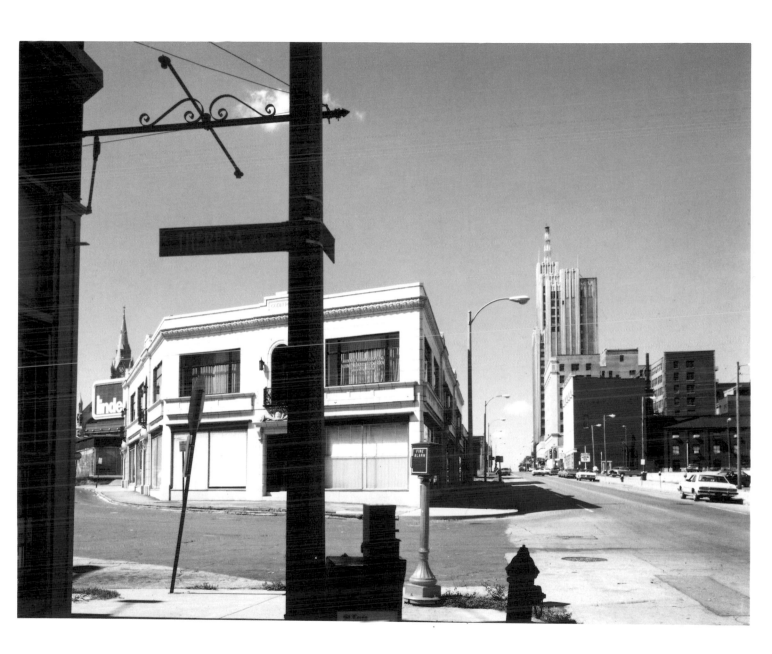

St. Louis, 1977

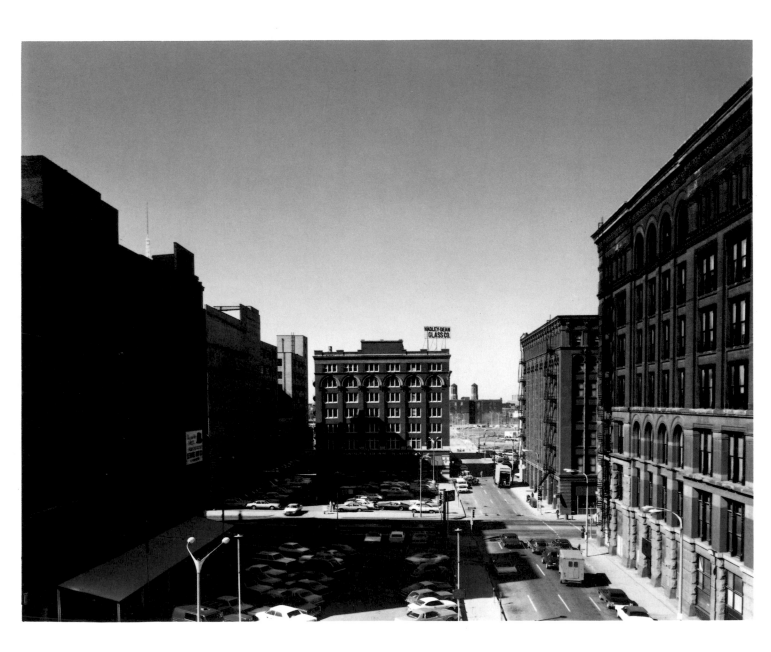

38 **St. Louis, 1978**

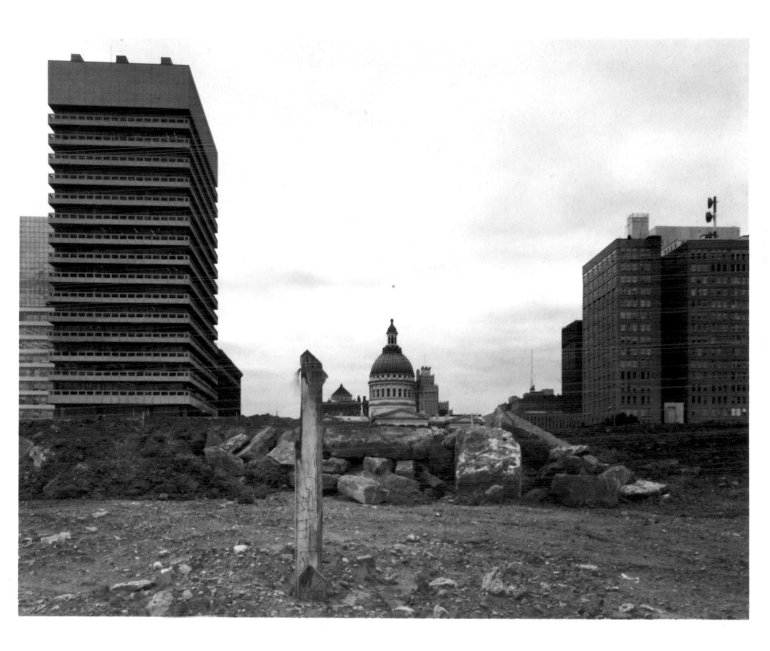

St. Louis, 1978

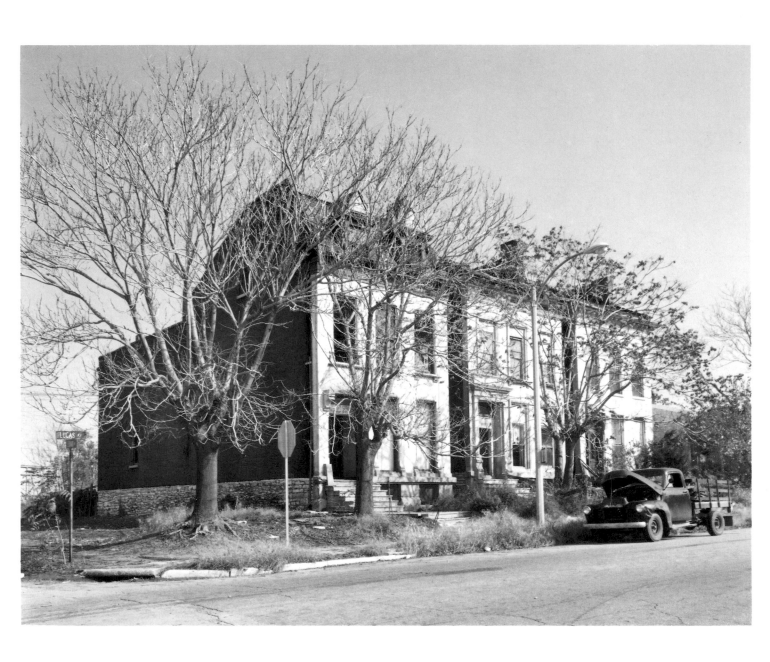

40 **St. Louis, 1977**

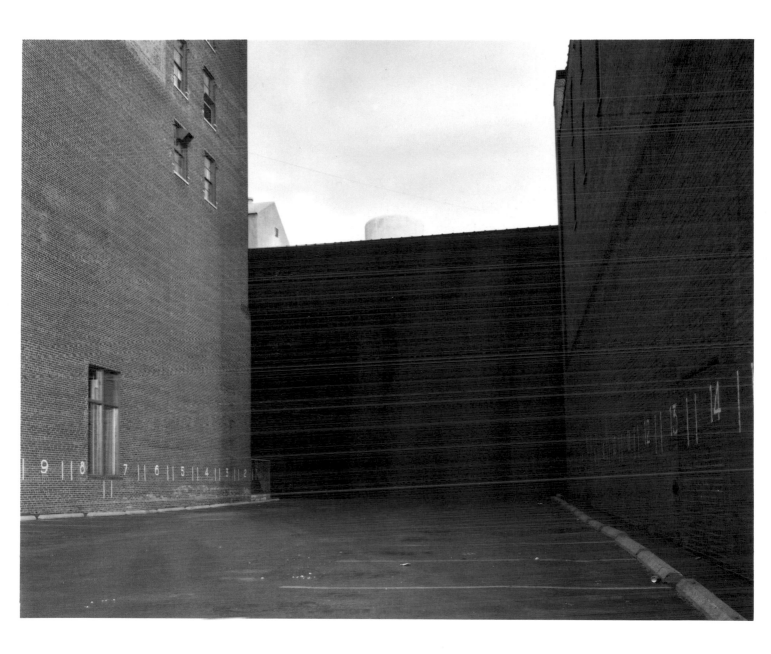

41 **St. Louis, 1978**

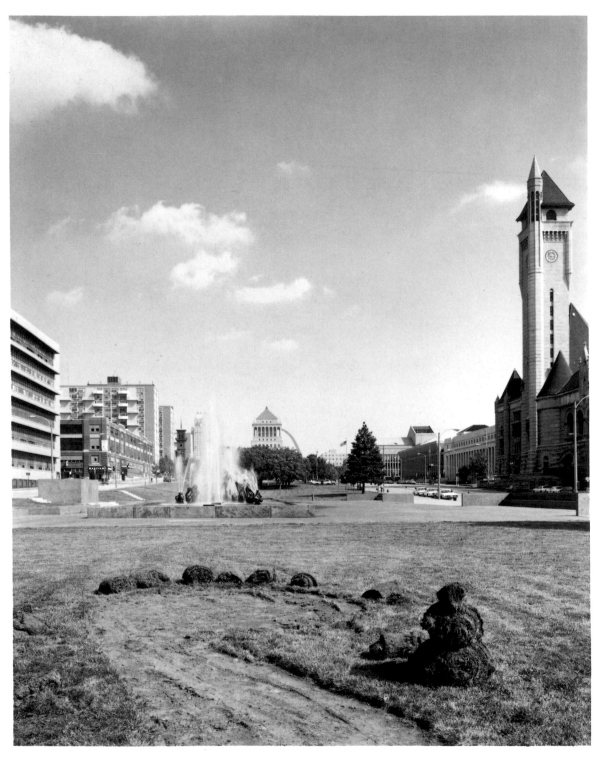

St. Louis, 1977

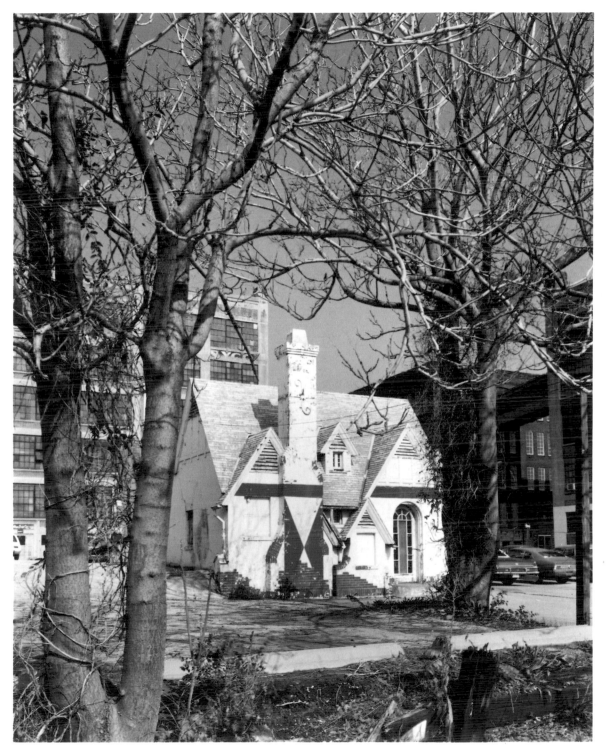

St. Louis, 1977

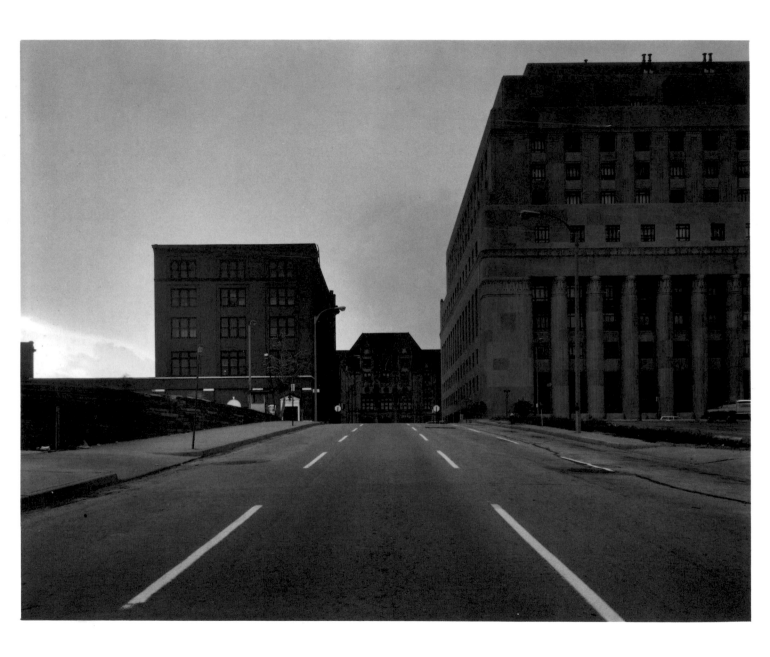

St. Louis, 1978

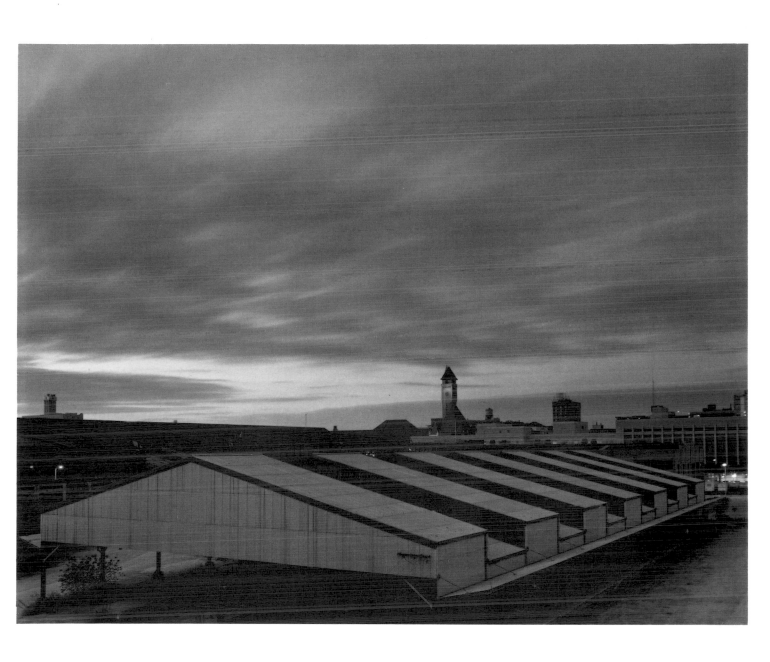

45 **St. Louis, 1978**

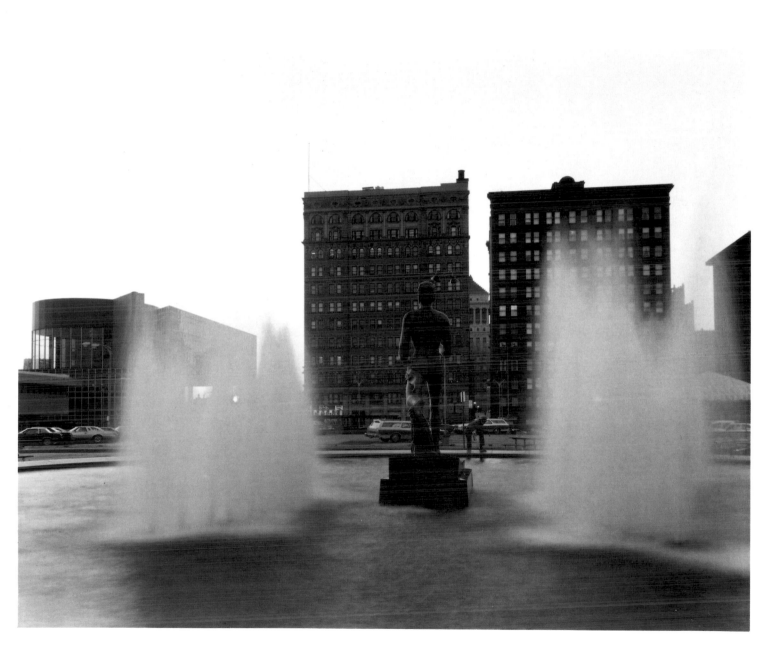

St. Louis, 1977

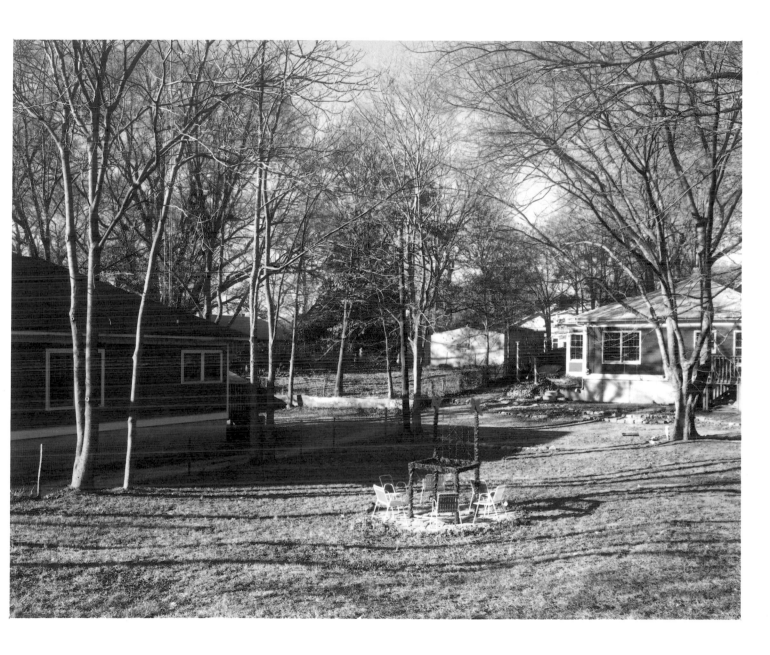

49 **Atlanta, 1988**

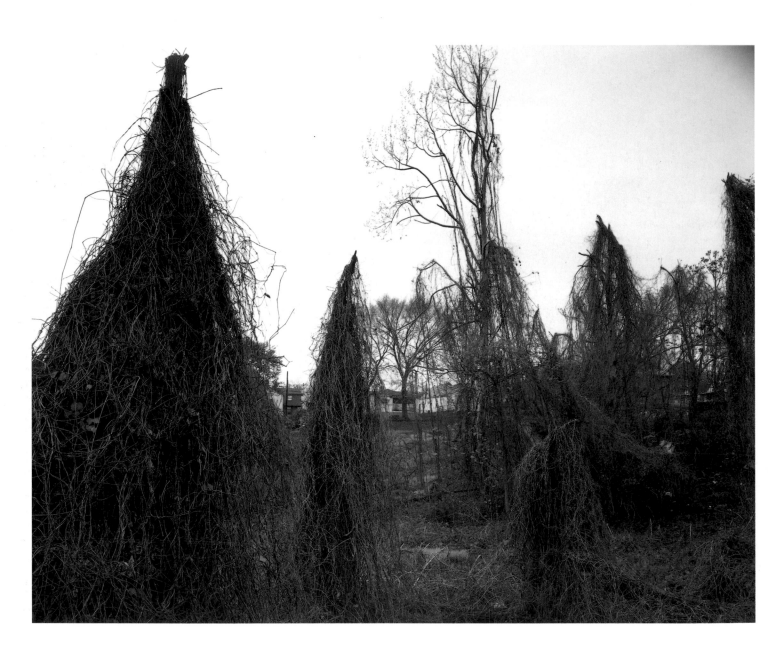

Atlanta, 1989

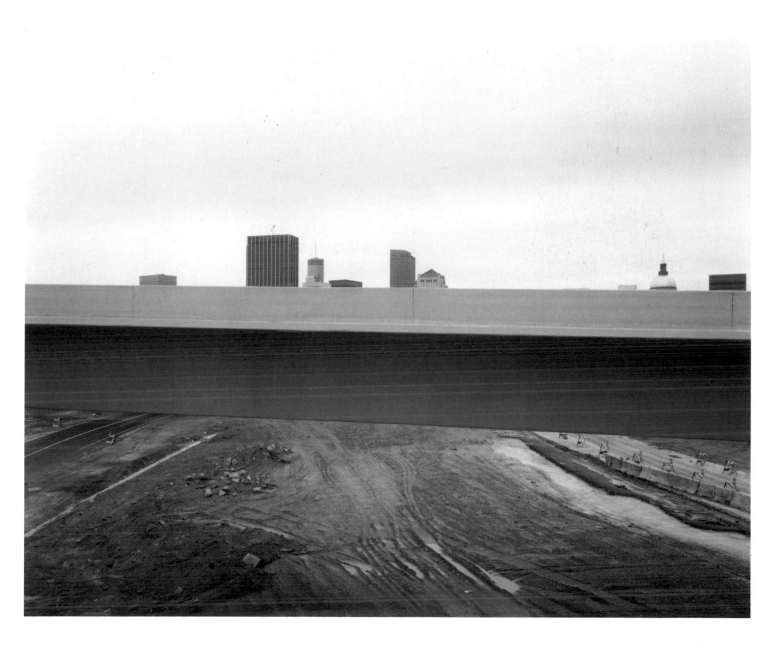

Atlanta, 1989

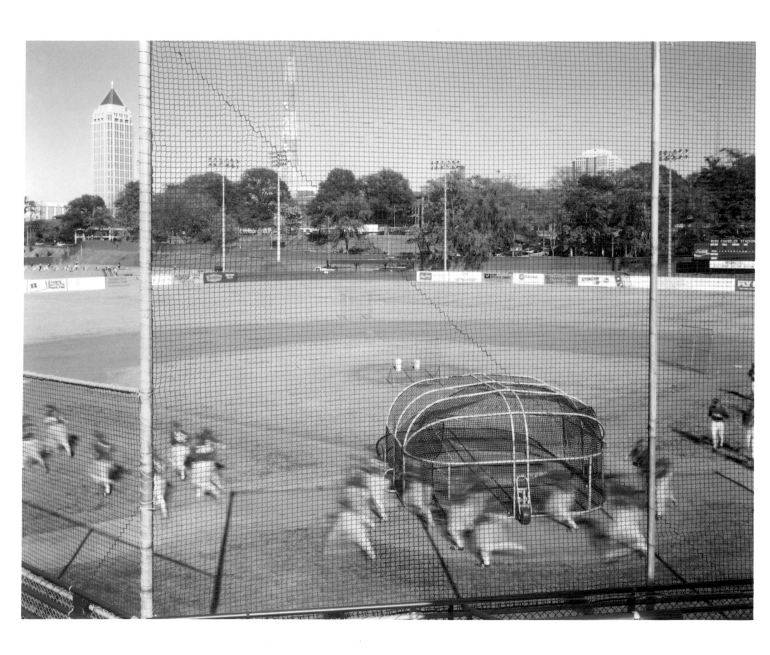

53 **Atlanta, 1988**

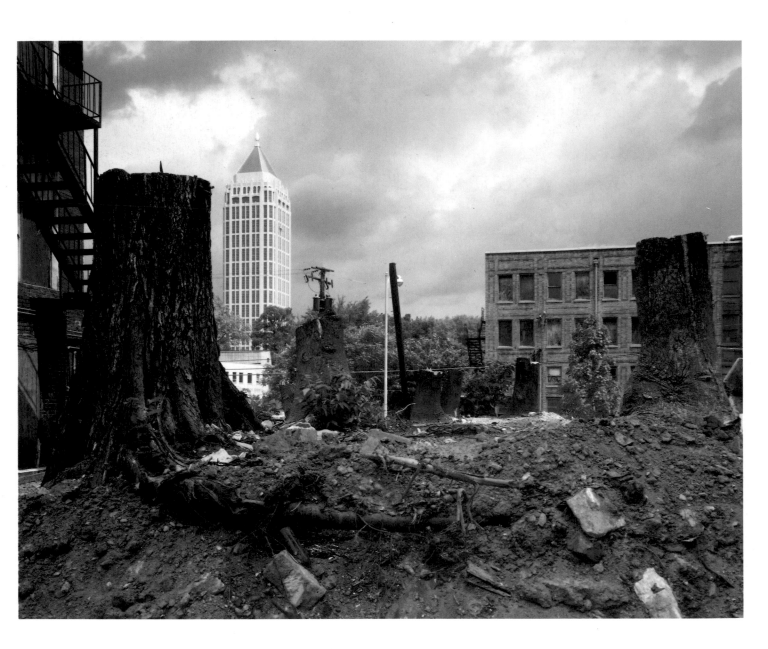

Atlanta, 1988

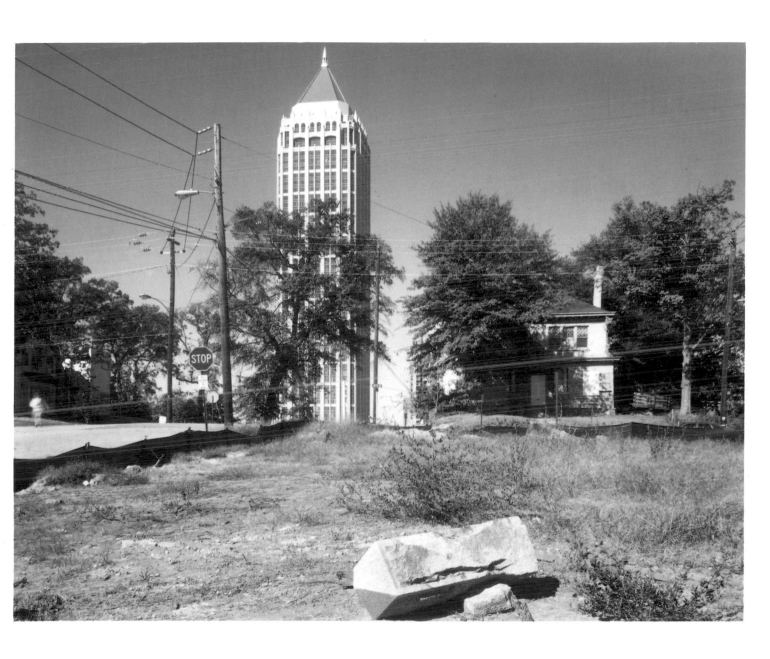

Atlanta, 1988

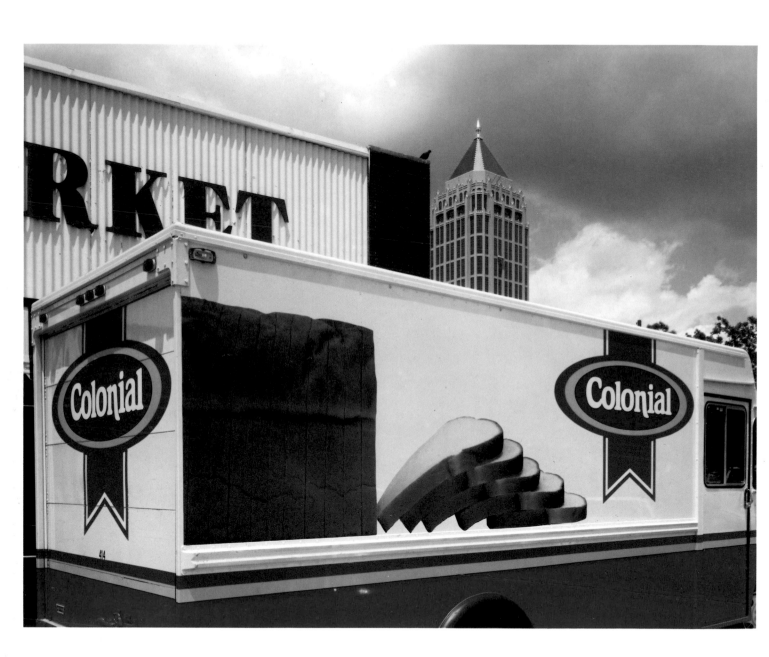

Atlanta, 1988

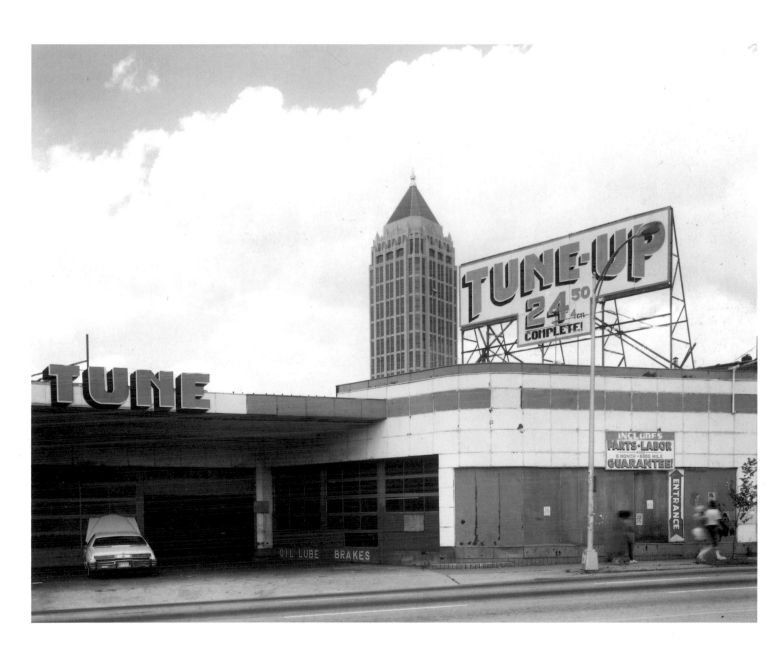

Atlanta, 1988

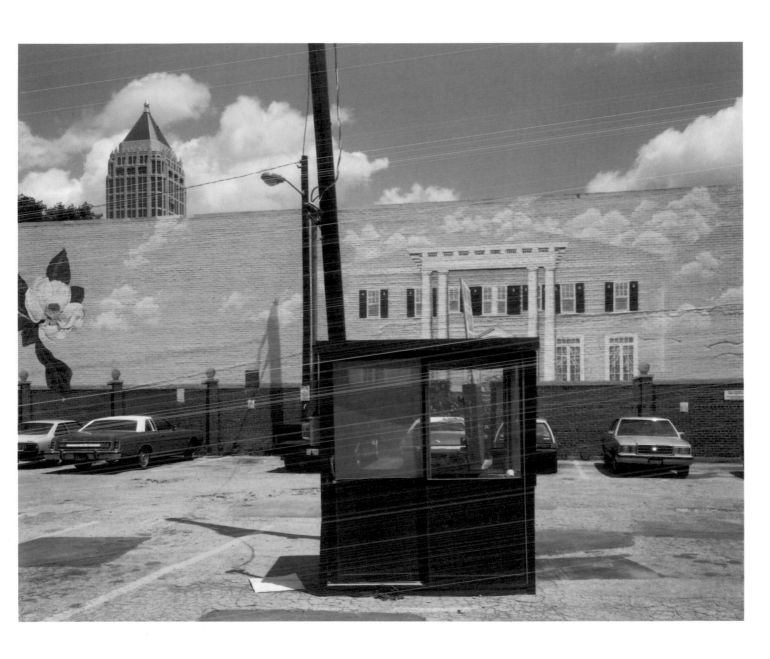

59 **Atlanta, 1988**

Joel Meyerowitz

Since the 1970s Joel Meyerowitz has concentrated on the American landscape, social as well as physical, exploring the spirit of places such as Cape Cod, St. Louis, and Atlanta. His photographs are marked by an acute visual intelligence and a sensitivity to the nuance of atmosphere and colored light, to the texture and mood of everyday life. They distill the essence of the familiar to reveal its extraordinariness, and show us the commonplace as a gateway to the mysterious.

Born in 1938 in New York City, where he lives, Meyerowitz studied painting and medical illustration at Ohio State University, receiving a BFA in 1959. He began his career as a photographer in the 1960s by photographing urban street incidents in 35mm black and white, along with photographers such as Lee Friedlander and Garry Winogrand. Describing himself as a product of "the street school," he credits the photographs of Robert Frank, Eugène Atget, and Henri Cartier-Bresson as the major early influences that sparked his interest in photography. He also admires the work of Brassaï, André Kertész, and Walker Evans. However, it was Meyerowitz's admiration of Frank's book *The Americans* (1955) that inspired him to change his career as art director in an advertising agency. "In the pantheon of greats there is Robert Frank and there is Atget," Meyerowitz says. "Interestingly enough, they are two poles that I have gravitated toward—one using the small camera and instantaneous responses, and the other with a view camera and a slow, caring, meditative look at places. Those two visions of the world captivated me early on, opened me up." While his earlier style was closely aligned with Frank's, his present way of working more closely resembles that of Atget, who used the 8 × 10-inch view camera to photograph French landscapes in the early part of this century.

Meyerowitz has received numerous awards, including two Guggenheim Fellowships (1971, 1978) and grants from the National Endowment for the Arts and the Humanities. In 1981 he was selected Photographer of the Year by the Friends of Photography. Meyerowitz's major photographic projects have been published as books, among them *Cape Light* (1978) and *St. Louis and the Arch* (1980; both New York Graphic Society). Other books include *Wildflowers* (New York Graphic Society, 1983), and *A Summer's Day* (Times Books, 1985). In 1989 he was commissioned by IBM to create a photographic profile of the city of Atlanta for their new building, which was designed by Philip Johnson. In addition to photographing landscape, Meyerowitz has also become known for his portraits of redheads, a collection of which will be published in a forthcoming book.

Extremely thoughtful about photography, Meyerowitz eloquently expresses the power of the medium, and his relation to it. "I think that to serve photography is the very best that one can do—not to try to dominate it or master it, but to just go with it, and to trust it to tell you things about yourself and about your world and how you respond to it. Fame and success are not the goals. The goal is to understand something of the medium's power, and something about how you are in the world, how it makes you see. Response, intelligence, clarity of intuition all are essential. Somebody goes out again and again, stands still for a moment, then brings us back a message that stands for a whole time. Look at what Atget did."

Meyerowitz too is investigating the beauties of form and the various descriptions offered by light, while he continues to examine and reveal his own relationships with the world, and with the self.

Technical information

In the 1960s Meyerowitz used a 35mm Leica rangefinder camera. Although he worked mainly in black-and-white for many years, he began experimenting with negative color film prior to changing to the large-format camera. Today Meyerowitz uses an 8 x 10-inch Deardorff view camera with a 10-inch Ektar wide-field lens, and works exclusively in color, preferring Kodak Vericolor II Type L film. He does not use filters, and does not bracket his exposures, and processes and prints his own work. He keeps a detailed log of each photograph, including the light, the quality of the day, the colors of the subject, the warmth or coolness of the shadows, and uses this as a guide when making his final Ektacolor prints.